PitchBlank Comic

Fill It In!

THANKS for choosing a PITCHBLANK COMIC BOOK! The only comic book that gets MORE exciting the longer you own it. You aren't just holding a blank canvas, you're holding the FIRST copy of YOUR New Creation! This book is designed to easily become a six-part Graphic Novel or six full Comics! It's YOUR book, YOU are the author and artist. You can choose to make it however you want. The important thing is that you get to SKIP the hard parts, and do the FUN part, the WRITING and DRAWING!

EVERYONE has a story to tell! What's YOURS? From the farthest reaches of your IMAGINATION to ADVENTURES you've had yourself, nothing tells a TALE like a graphic novel. We want you to accomplish the fun part of this process, the storytelling and drawing. PITCHBLANK COMICS takes care of the difficulty of FRAMING and lets YOU get on with the CREATIVITY. Sometimes a little confinement allows us more freedom.

When you have finished we'll show you how to convert your work into a COMPLETE book with nothing but your OWN artwork between your CUSTOM covers.

We have no doubt you can finish this book by yourself, but to make it even EASIER we have included a simple guide for organizing your story. Remember, creativity is in YOU, and you shouldn't follow instructions if you don't want to. The less rules you follow the more CREATIVE you can get!

Guide:

Before you begin to fill in the blanks you may want to do a little planning...

Most stories are about a character or group of characters doing something that is interesting. It is probably a good idea to think about who or what your characters are and what it is that they will be doing and write down as many details as you can. The order of events in most stories is:

1. Character Introduction
2. Rising Action
3. Climax
4. Resolution

Organize the main events of your story into these four groups. Next, look through the blank panels to decide where to place the major events, you can then fill in the smaller squares and connect everything together. Larger panels work best for turning points, establishing shots, action scenes and their results. Smaller panes, especially a series of them, can be used for sequential events, back and forth dialogue, and simpler occurrences. The full pages can be used as comic covers, chapter openings or closings or whatever else you can think of.

Remember, you have to fit your whole story in and wrap it up before you run out of room. To help you know how much space you have, we have broken this 120 page comic into six parts. Each of these sections have page numbers that move from the left to right indicating where in the section you are. When the page number is on the right side you know you're nearing the end of that section.

Tips:

- Draw however you want! People like Comics because they express their creator!

- Drawing lightly in pencil first will allow you to make changes, when everything is finished you can go back and trace your lines in ink.

- Remember to plan the characters, events, and setting of your story and what it all will look like.

- When a scene changes to a new location you can draw a picture with a lot of background detail so that the reader knows where the story is now taking place.

- Use eye contact between characters to make their interactions feel more realistic.

- The Flow from panel to panel is usually left to right, top to bottom.

- Word bubbles look best if you write the words and then draw the bubble.

- Write word bubbles before drawing the picture.

- In comics the lettering is usually ALL CAPITALS

- Embolden certain words to give them emphasis

- To figure out what a mouth looks like saying a phrase, you can take a video of someone saying the line and pause it to check the mouth position.

- Turn the whole book sideways to change the layout of the panels to a Landscape format.

- When planning your story outline you can look ahead at the boxes and note the relative position of each box using a sequence like this...

 A B C

 D E F

 G H I

 Assign each box a letter or letters to keep track of how big each box is and where on the page it is located.

- If necessary, you can always cut pages out with scissors and rearrange them to suit your story.

Completing your work

When you have finished your story, you can complete your project and have a finished graphic novel of your own creation. You can cut or tear out this introduction and put it somewhere safe for further reference.

If you want, you can make a cover for your book. Take a large sheet of paper and fold a portion of it behind the front cover. Wrap it around the spine of the book to the back page and fold it over and behind the back cover. Now that you have it fit, tape the ends over the covers.

Next, you can draw a title and create an illustration for your new cover and maybe you will want to add an about the author section and draw your author picture on the back!

We hope you get started on your project right away!

FIND MORE at www.pitchblankcomics.com

THANKS and Have FUN!!!

-Jeff Zeiss and Danny Morgan

3

4

15

23

24

42

48

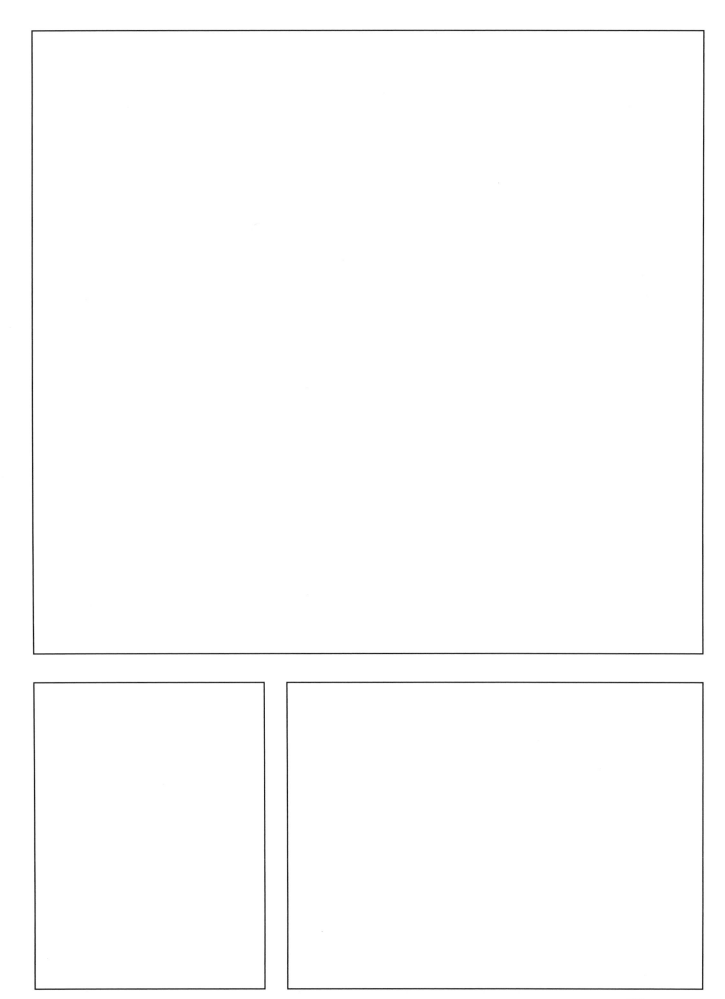



63

83

84

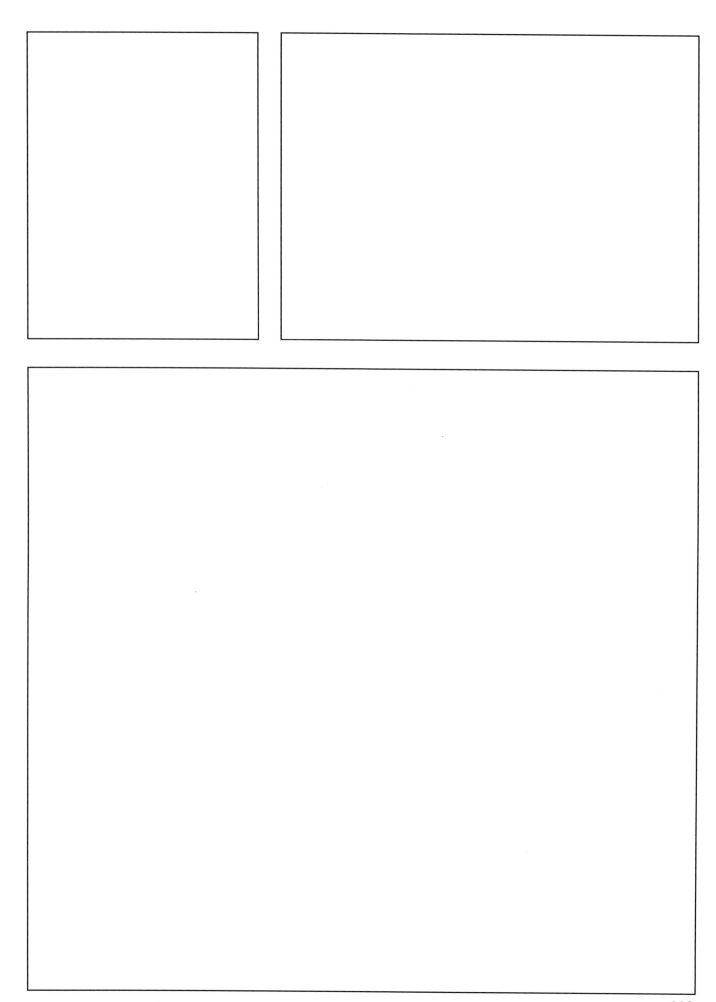

Made in the USA
Columbia, SC
18 December 2020